Compostion

Photographs by Stefan Szczelkun

ISBN 9781-870736-17-6
Routine Art Co.
London 2018

Compostion SDIM1536.jpg
3106 x 2357
ISO 100 30mm f/4.5 1.0s
11th April

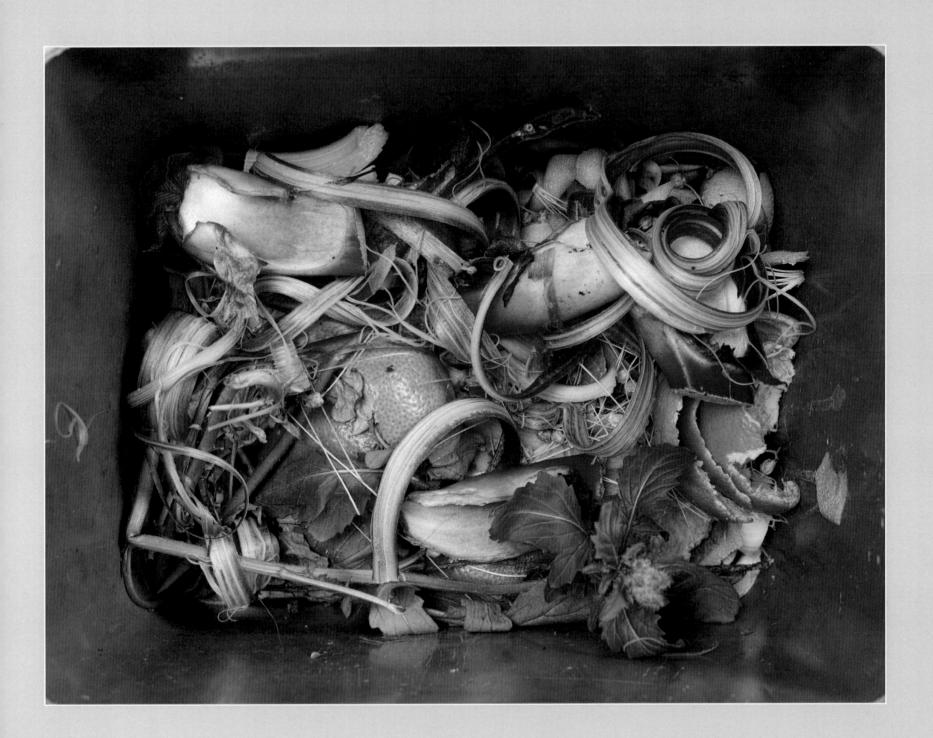

Compostion SDIM0456.jpg
2940 x 2240
ISO 200 30mm f/6.3 1/15s
8th May

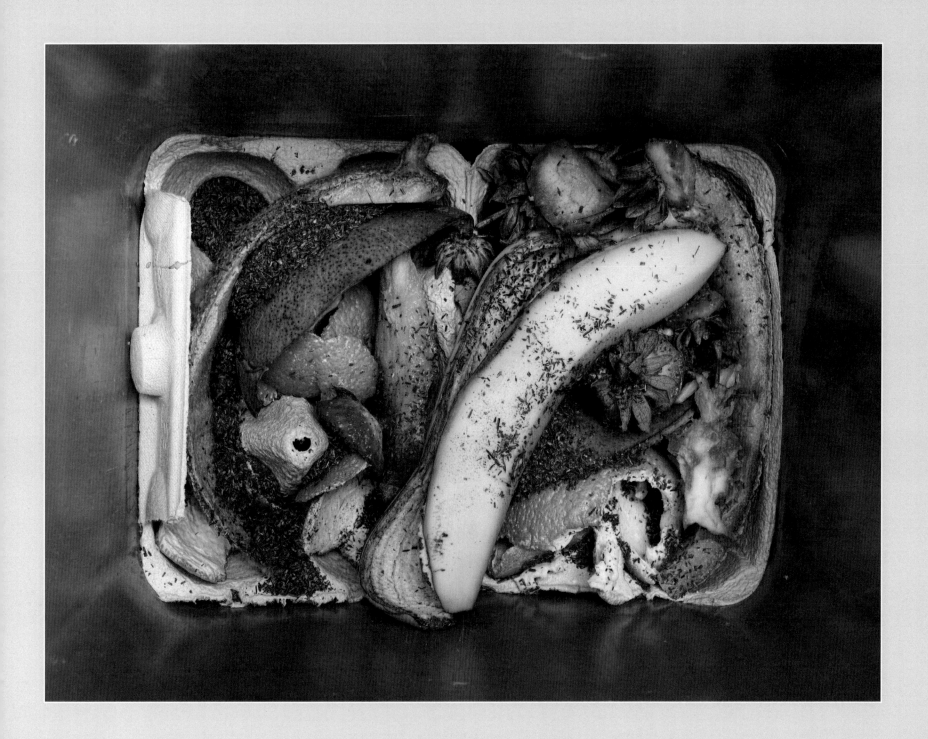

Compostion SDIM0529.jpg
3549 x 2770
ISO 200 30mm f/5 1/200s
24th June

Compostion SDIM0529.jpg
3549 x 2770
ISO 200 30mm f/5 1/200s
24th June

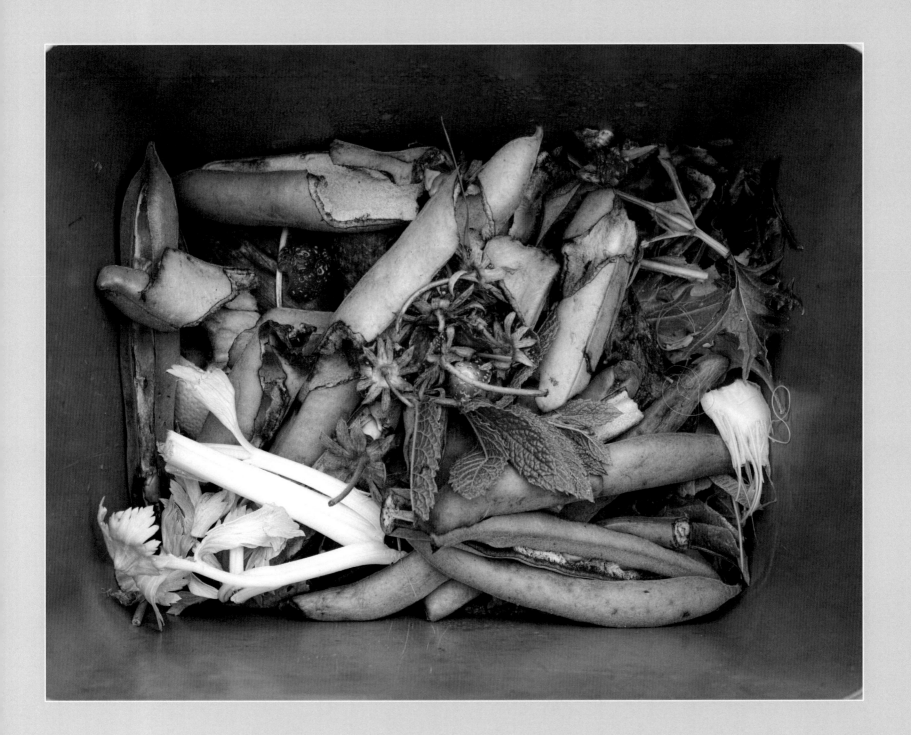

Compostion SDIM1255.jpg
3075 x 2241
ISO 100 30mm f/3.2 0.30000s
7th July

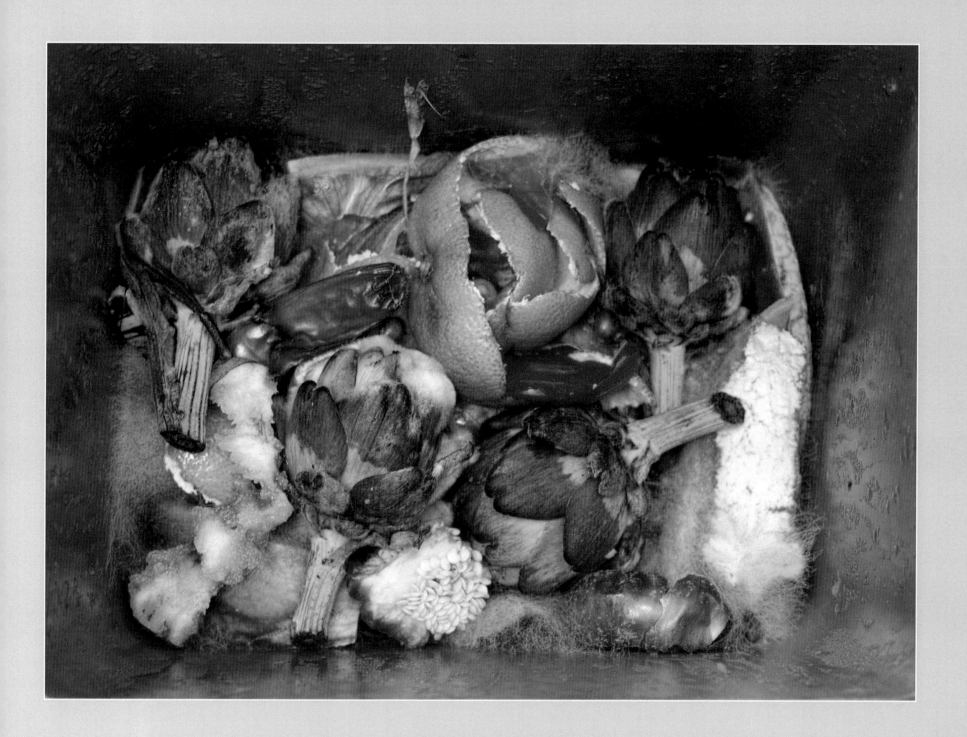

Compostion SDIM1332.jpg
3060 x 2303
ISO 100 30mm f/4.5 1/4s
25th August

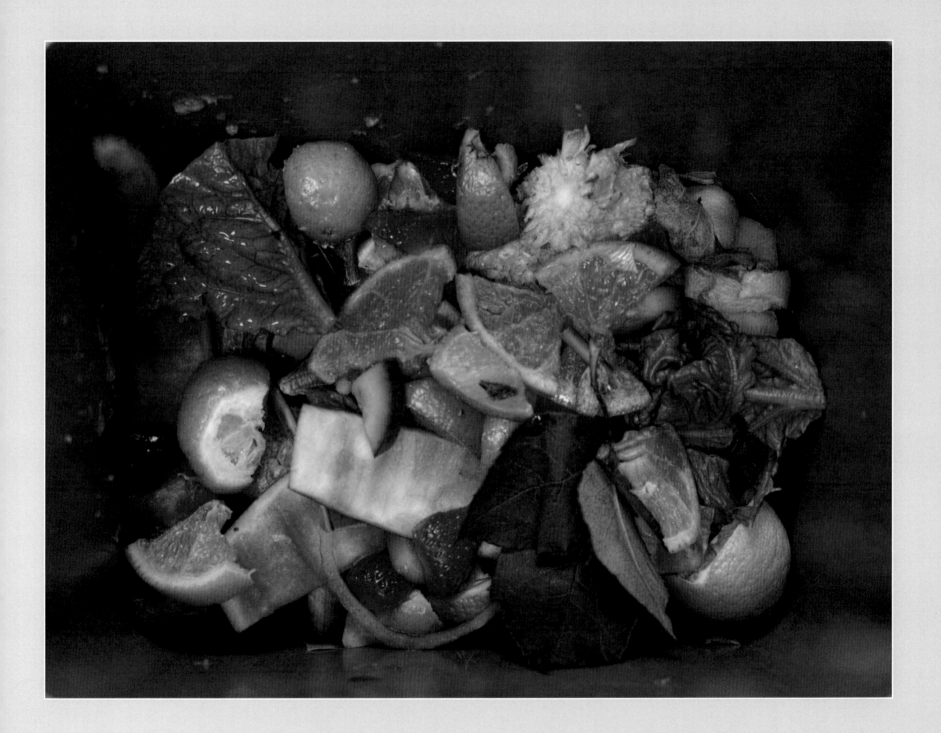

Compostion SDIM0766.jpg
3131 x 2385
ISO 100 30mm f/2.8 1/6s
4th September

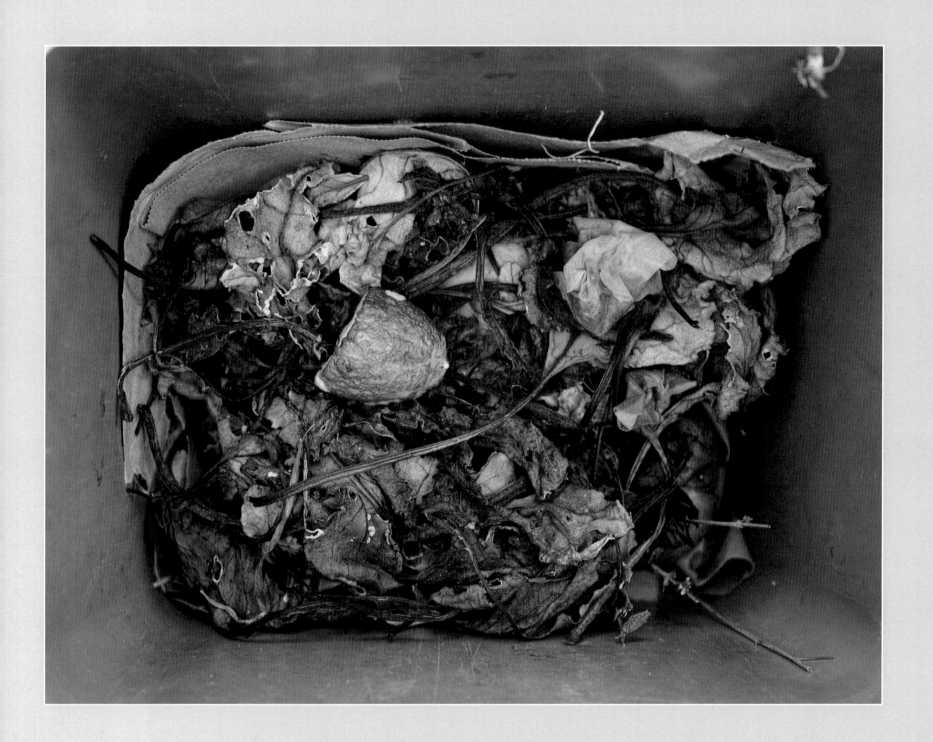

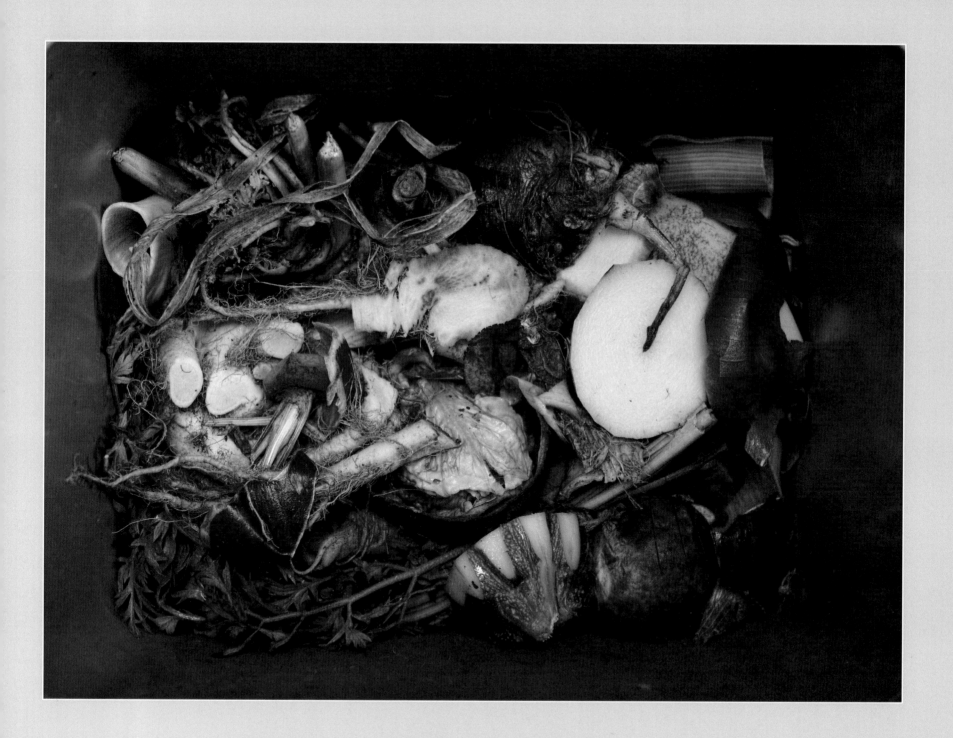

Compostion SDIM0890.jpg
3158 x 2177
ISO 100 30mm f/5 0.5s
30th October

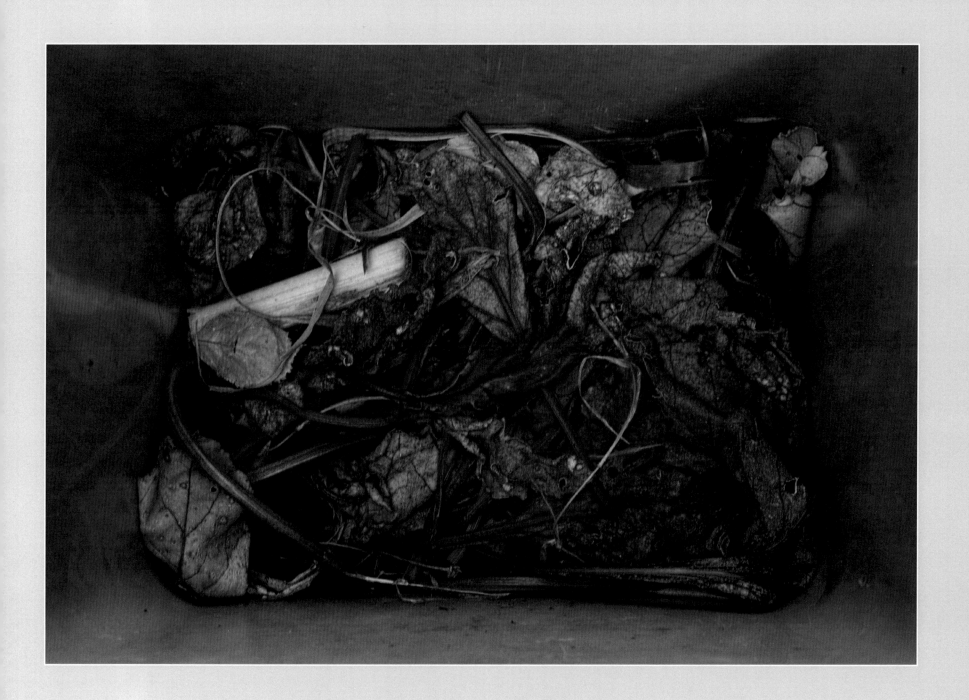

Compostion SDIM0891.jpg
3194 x 2376
ISO 100 30mm f/5 2.5s
31st October

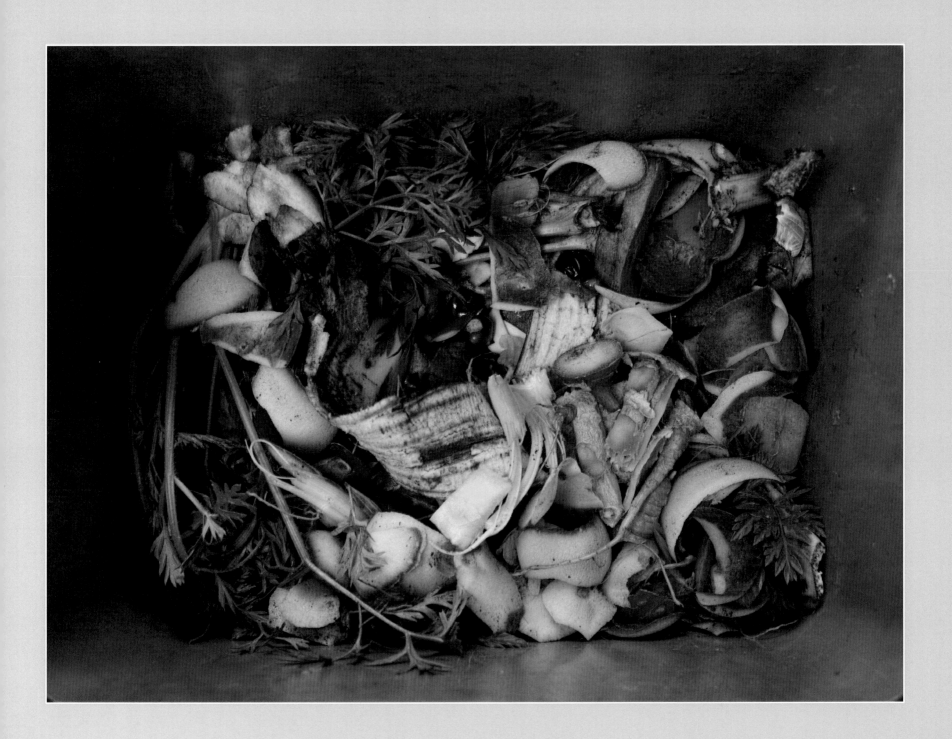

Compostion SDIM0907.jpg
2183 x 1690
ISO 100 30mm f/2.8 0.6s
2nd November

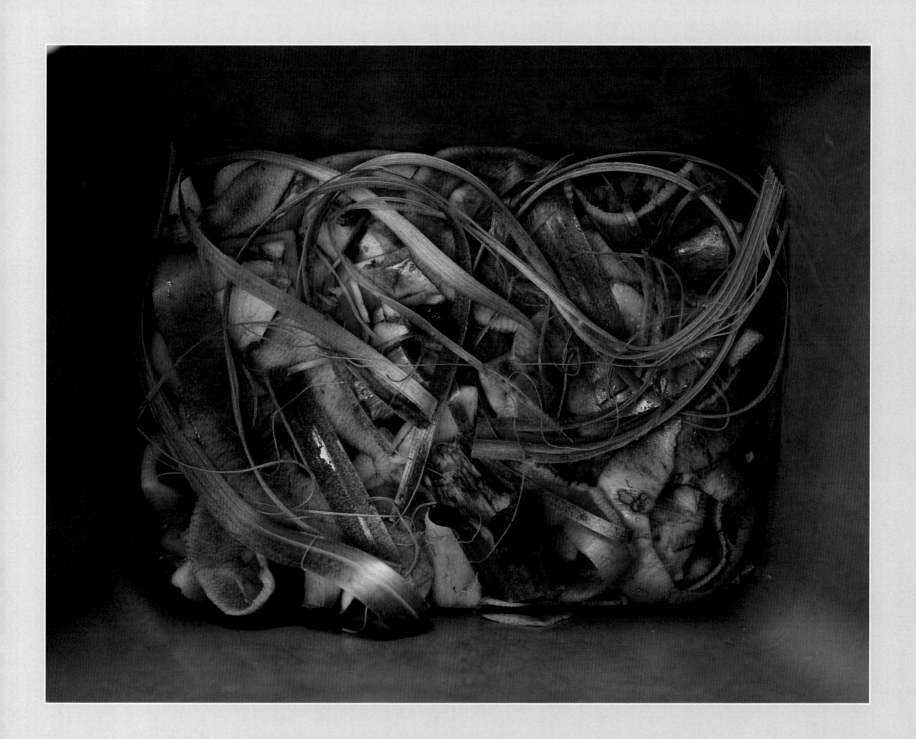

Compostion SDIM1390.jpg
3643 x 2676
ISO 100 30mm f/2.8 1/20s
29th November

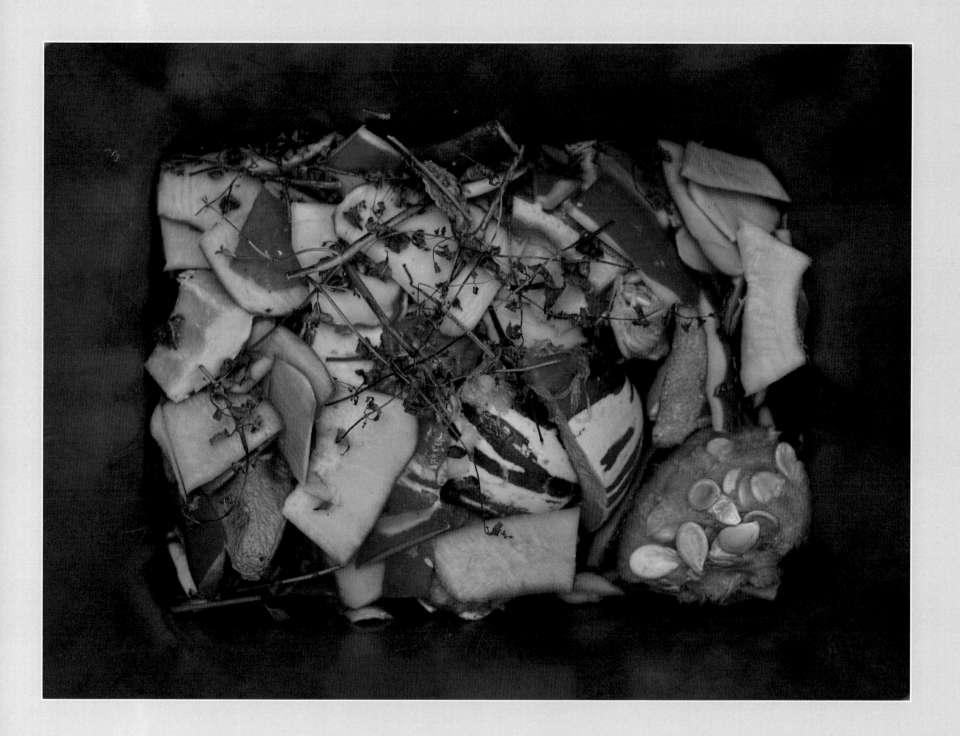

Compostion SDIM0971.jpg
2367 x 1841
ISO 100 30mm f/4.5 3.2s
2nd December

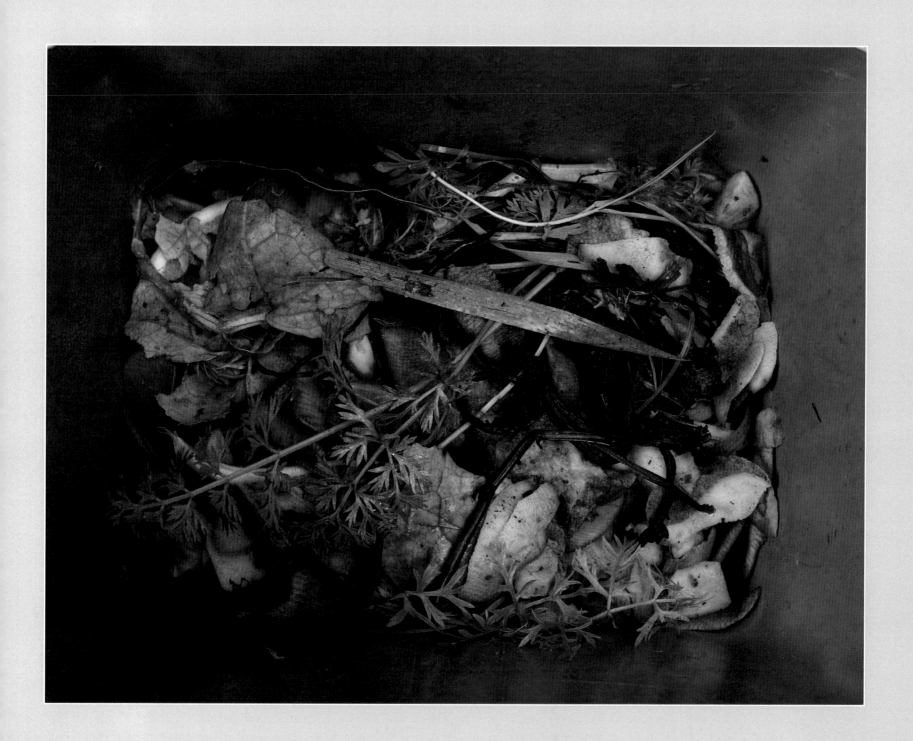

Compostion SDIM0999.jpg
2176 x 1497
ISO 100 30mm f/4 4.0s
21st December

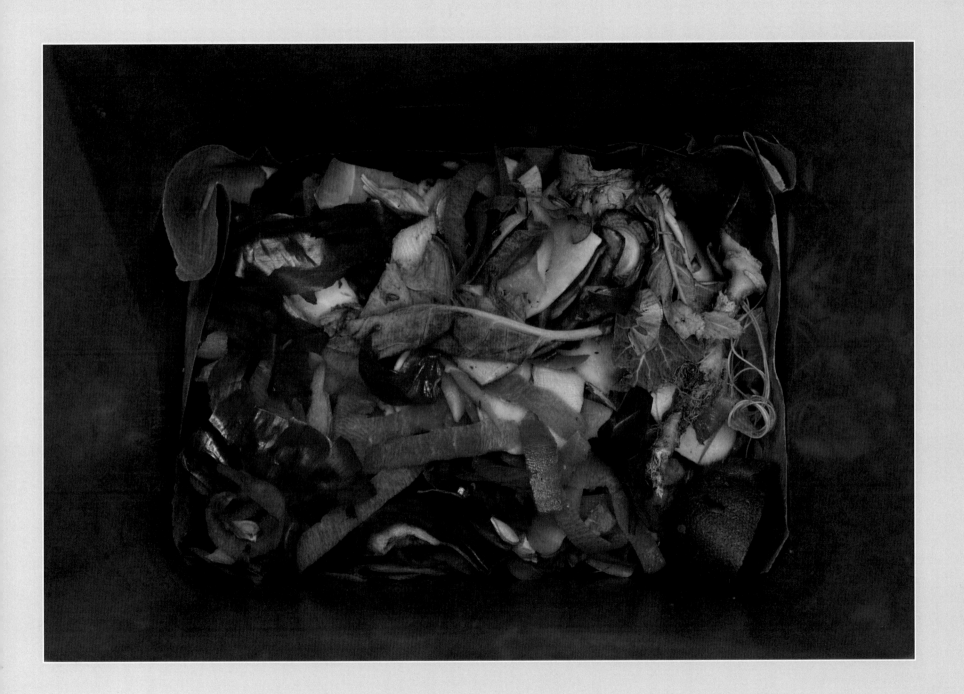

Compostion SDIM1014.jpg
2059 x 1510
ISO 200 30mm f/10 0.8s
28th December

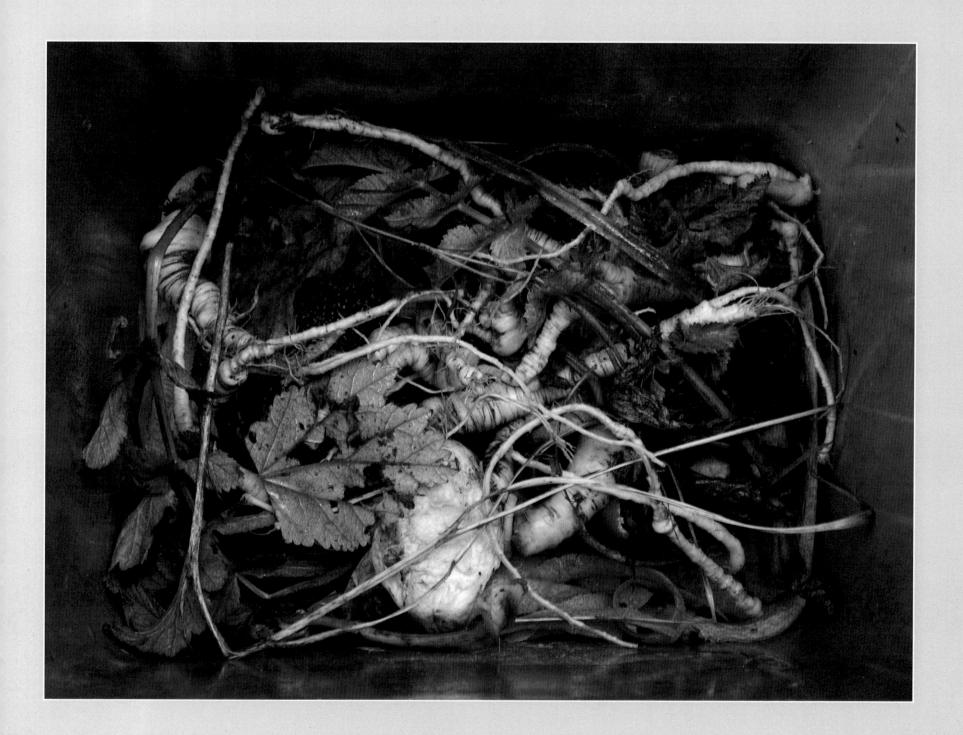

Compostion SDIM1115.jpg
3287 x 2394
ISO 100 30mm f/8 1.6s
25th February

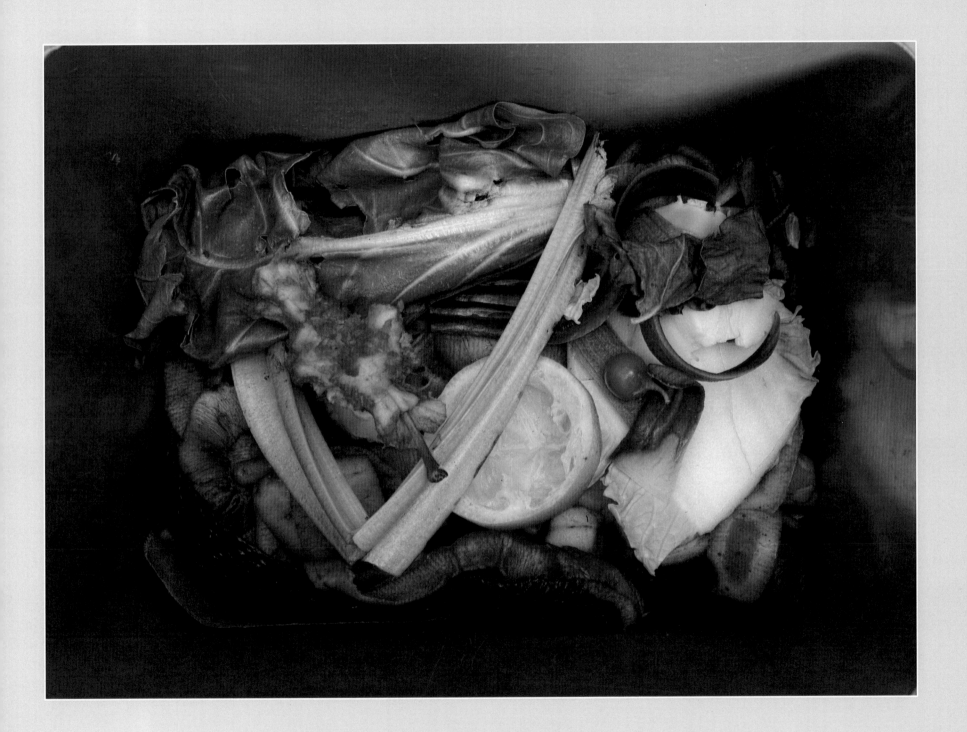

Compostion SDIM0252.jpg
1837 x 1403
ISO 200 30mm f/2.8 1/40s
16th March

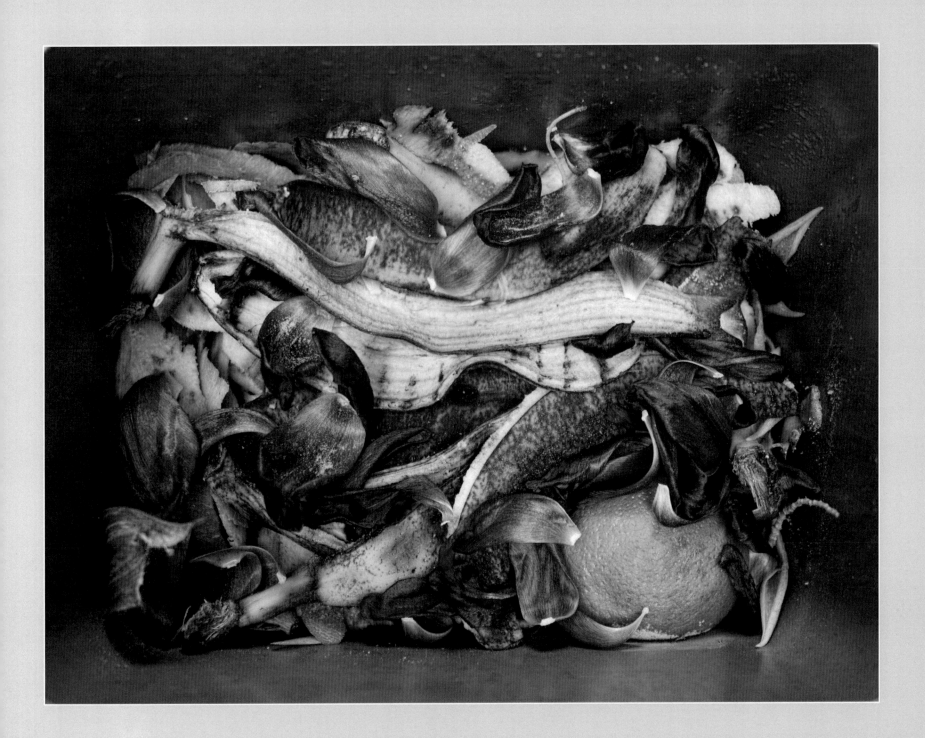

Compostion SDIM0298.jpg
1802 x 1381
ISO 200 30mm f/2.8 1/60s
27th March

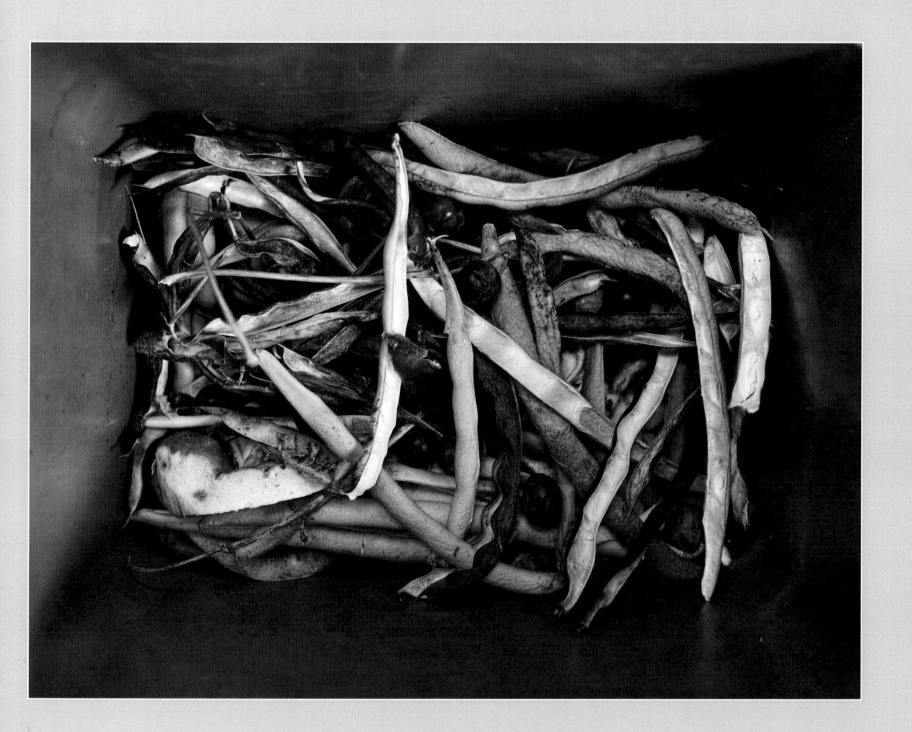

Afterword

Thanks to my wife Chloe who pointed out the potential beauty in a compost caddy by taking some pictures before I started on this series of photographs. I first used my iPhone 4S, but it was only when I got a Sigma DP2 camera with its Foveon sensor that the images began to 'pop'.

Finding beauty in chaos and decomposition appealed to my anarchist and anti-art sensibility. Representing still life or flora at the peak of its perfection reeks of petrified ideologies. Decomposition suggests that the formal relations we hold dear are subject to a continual state of change. Matter readied for breakdown by benign organisms reminds me that the world is 'on our side'. What is discarded can contribute to tomorrows new growth.

There are other ways of looking at these photographs. The seasons are partly represented by allotment produce and partly denied by unseasonal supermarket fare. Within these patterns the photos also give a partial picture of what we did and didn't eat during the two years or so that it took to do this project. There is also a way of seeing them as painterly compositions of abstracted colours and shapes that may have been a part of the subconscious criteria by which I would choose to take a photograph at any given moment. Was it a way of negotiating an escape from, or renewing, the compositional presets that every aspiring artist absorbs from his or her culture?

Or the photos could simply be used as an observational game to name the fruit and vegetables shown.

They were all shot with the ambient daylight from our kitchen skylights. The camera data on the facing page gives some idea of variations that this gives rise to.